Coloring Tools

Using whatever medium you like, you can take these delightful drawings into a new world of color. Different coloring tools can really lend different effects and moods to an illustration—for example, markers make a vibrant statement while colored pencils offer a softer feel. Have fun experimenting with some of these mediums:

- Markers
- Colored pencils
- Colored pens
- Gel pens
- Watercolors
- Crayons

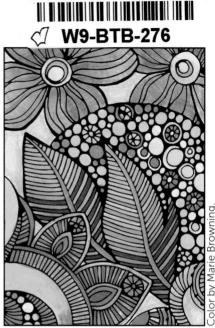

Color by Marie Browning.

Markers
Dual Brush Markers (Tombow).
Bright Tones.

Color by Marie Browning.

Colored Pencils
Irojiten Colored Pencils (Tombow).
Vivid Tones.

Color by Marie Browning.

Watercolors
Watercolors (Winsor & Newton).
Analogous Tones.

Color Theory

With color, illustrations take on a life of their own. Remember: when it comes to painting and coloring, there are no rules. The most fun part is to play with color, relax, and enjoy the process and the beautiful finished result. Feel free to mix and match colors and tones. Work your way from primary colors to secondary colors to tertiary colors, combining different tones to create all kinds of different effects. If you aren't familiar with color theory, here is a quick, easy guide to the basic colors and combinations you will be able to create.

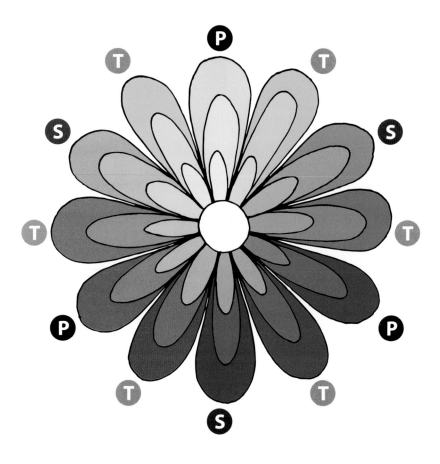

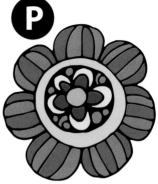

Primary colors: These are the colors that cannot be obtained by mixing any other colors; they are yellow, blue, and red.

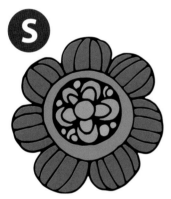

Secondary colors: These colors are obtained by mixing two primary colors in equal parts; they are green, purple, and orange.

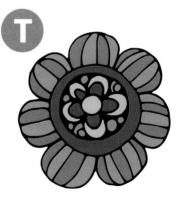

Tertiary colors: These colors are obtained by mixing one primary color and one secondary color.

Coloring Ideas

Color each section of the drawing (every general area, not every tiny shape) in one single color. This will take less time and can change the overall look of the drawing.

Within each section, color each detail (small shape) in alternating colors. This creates a nice varied and symmetrical effect.

Leave some areas white to add a sense of space and lightness to the illustration. Just because it's there doesn't mean it has to be colored!

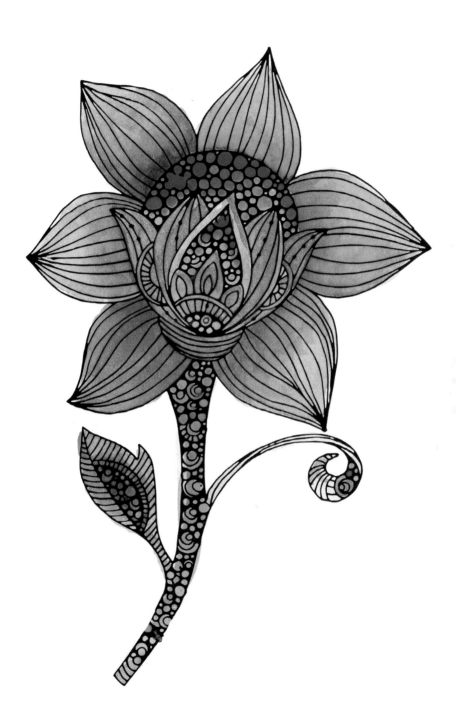

Watercolors (Winsor & Newton). Deep Tones.
Color by Marie Browning.

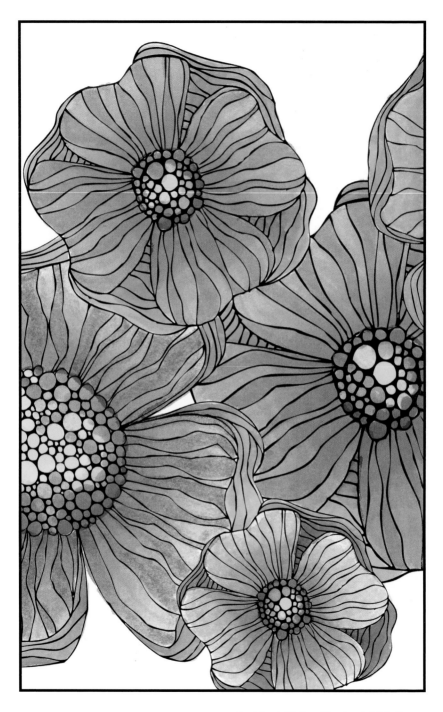

Dual Brush Markers (Tombow). Bright Tones.
Color by Marie Browning.

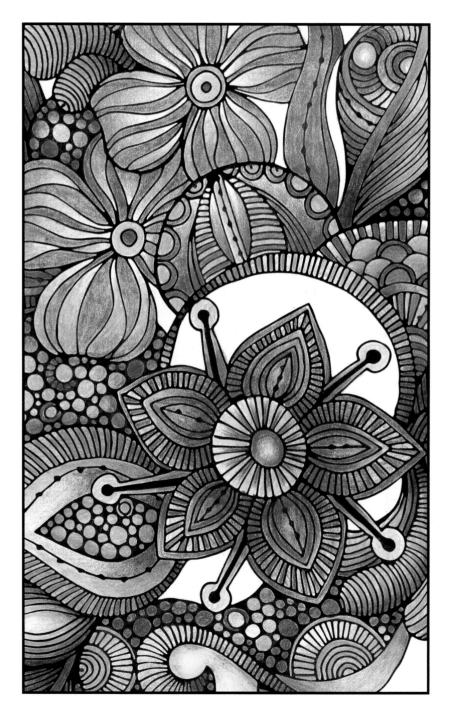

Irojiten Colored Pencils (Tombow). Vivid Tones.
Color by Marie Browning.

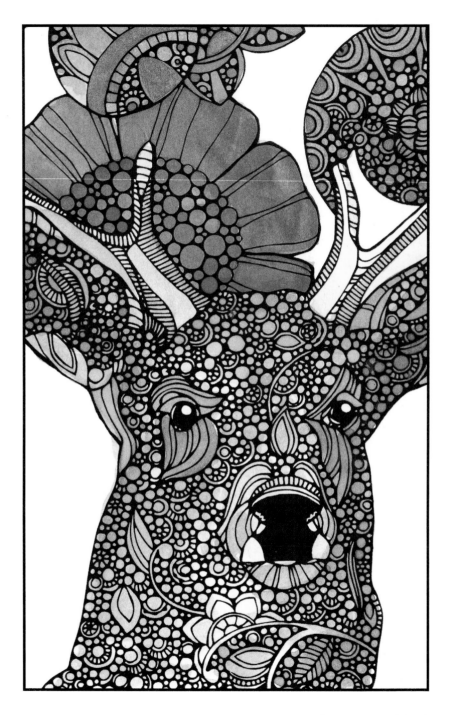

Watercolors (Winsor & Newton). Deep,
Natural Tones. Color by Marie Browning.

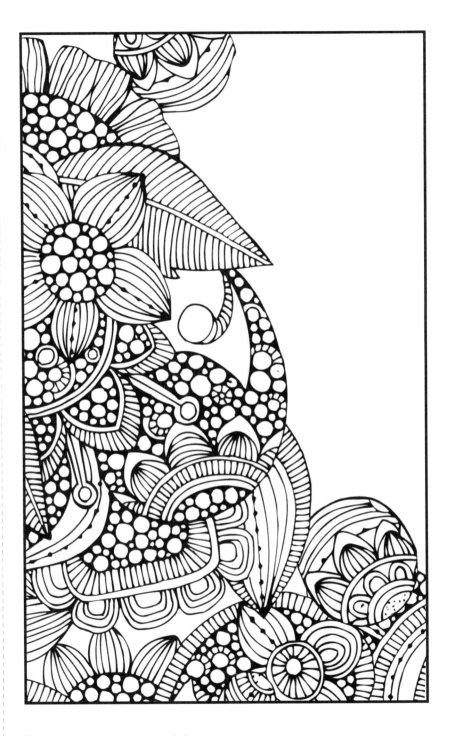

Your mind is a flower,
your thoughts are the seeds,
the harvest can either be
flowers or seeds.

—William Wordsworth

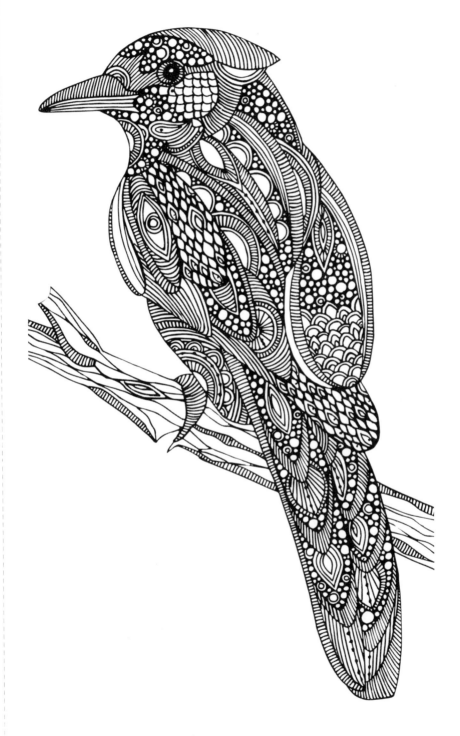

It takes courage to grow up and turn out
to be who you really are.

—e.e. cummings

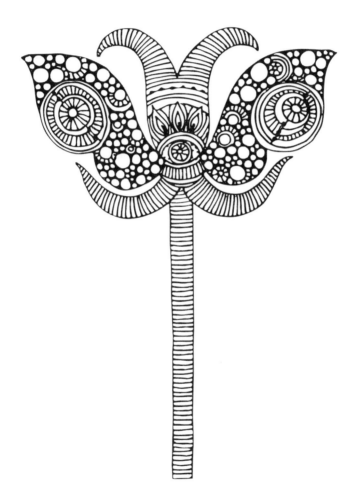

Those who dwell among the beauties
and mysteries of the earth are
never alone or weary of life.

—Rachel Carson

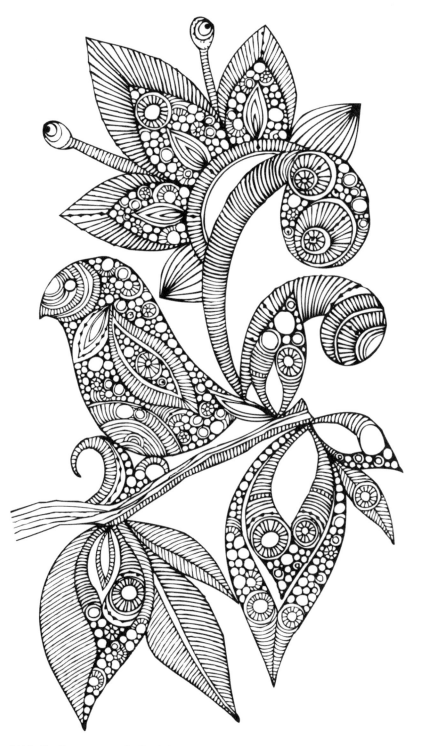

There are two gifts we should give
our children: one is roots, and the
other is wings.

—Unknown

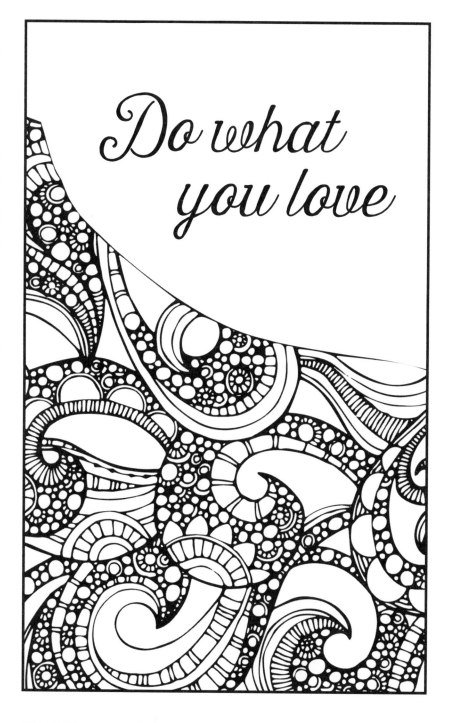

Do what you love

Not all those who wander are lost.

—J.R.R. Tolkien

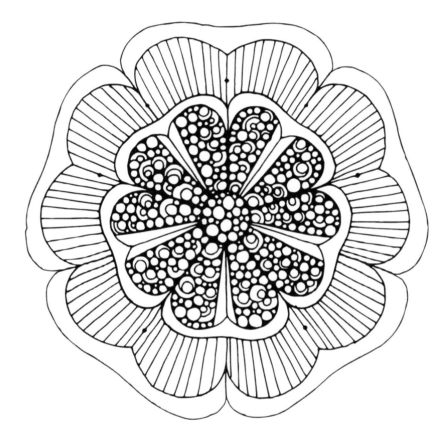

A dream is more powerful
than a thousand realities.

—Nathaniel Hawthorne

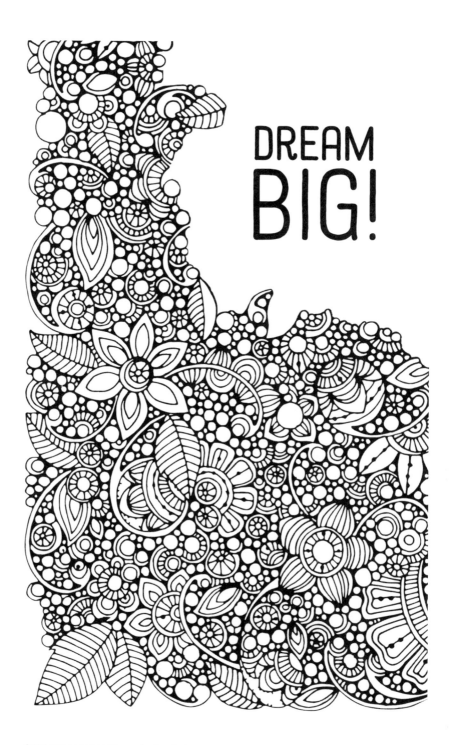

DREAM
BIG!

I have not failed. I've just found 10,000 ways that won't work.

—Thomas Edison

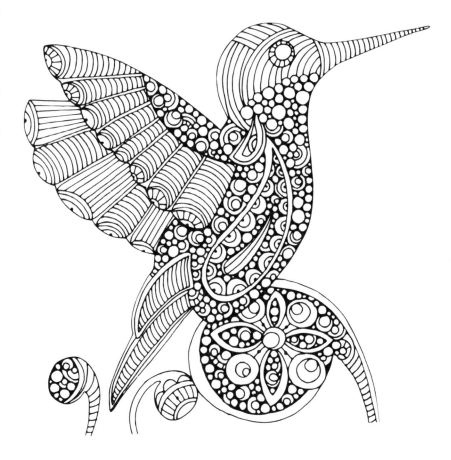

I always wonder why birds stay
in the same place when they can fly
anywhere on the earth. Then I ask
myself the same question.

—Harun Yahya

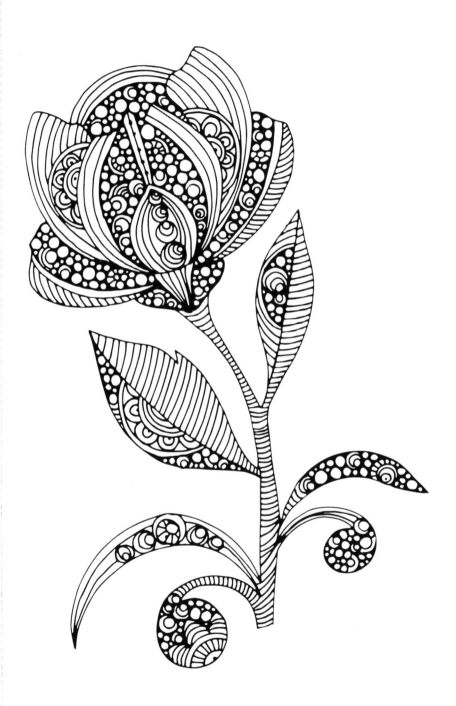

In seed time learn,
in harvest teach,
in winter enjoy.

—**William Blake**

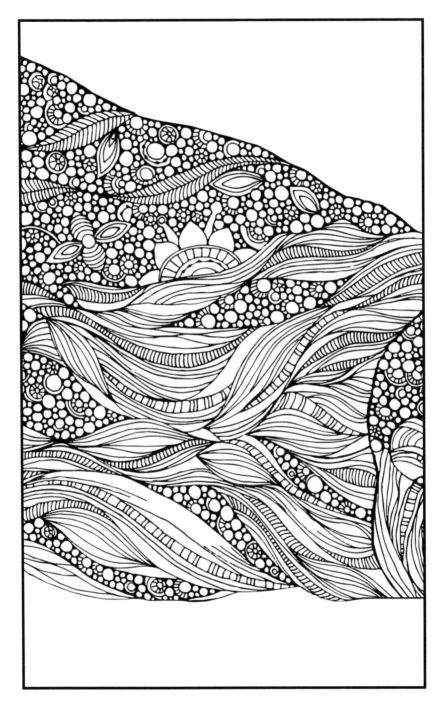

Choose your thoughts carefully.
Keep what brings you peace,
release what brings you suffering,
and know that happiness is just
a thought away.

—Nishan Panwar

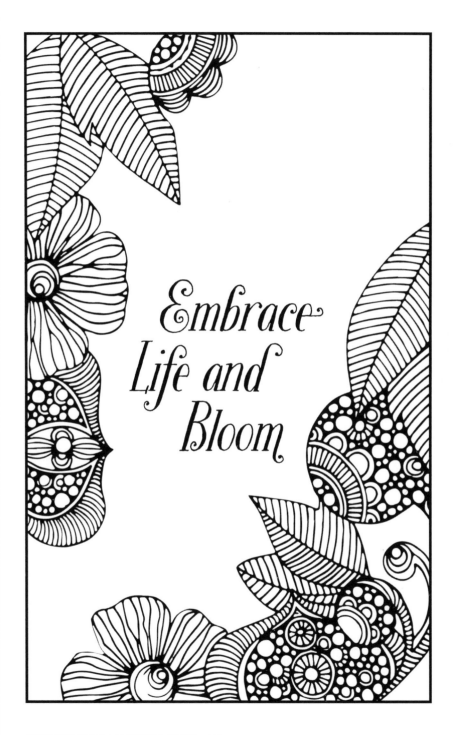

Embrace
Life and
Bloom

If you never chase your dreams,
you'll never catch them.

—Unknown

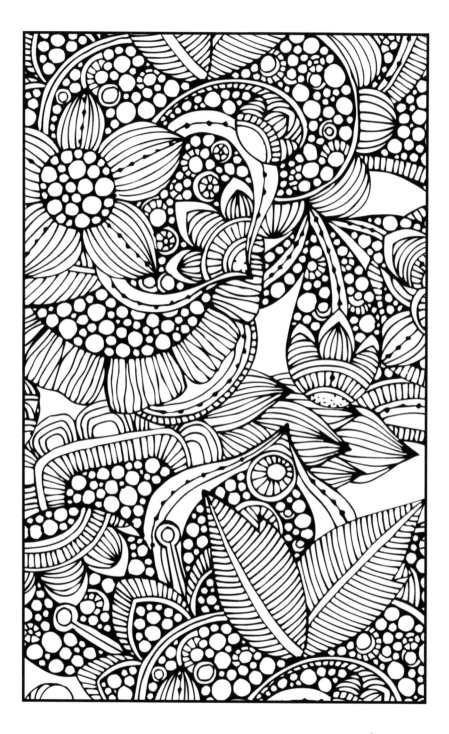

Create, grow, try and
expand, dare, jump and just see
where you land.

—Unknown

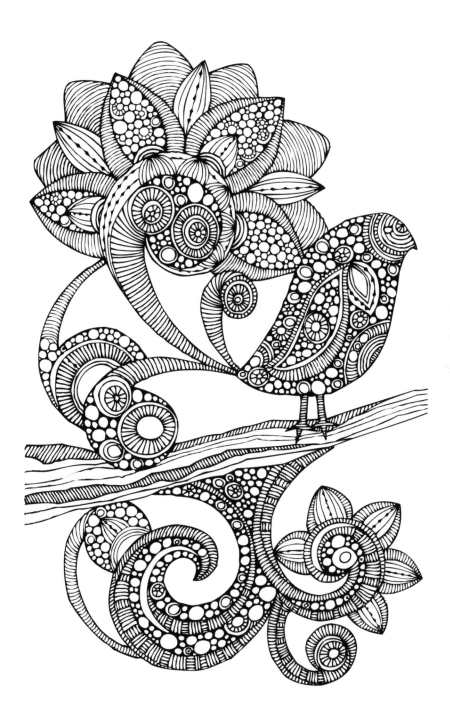

Be happy for this moment.
This moment is your life.

—Omar Khayyam

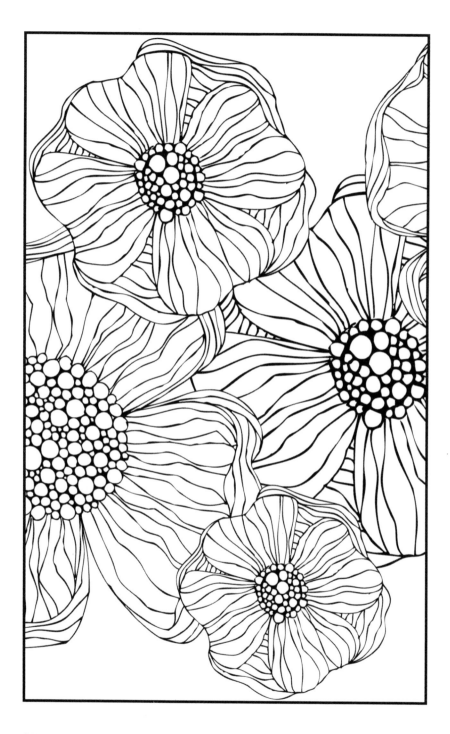

A flower cannot blossom
without sunshine, and man
cannot live without love.

—Max Müller

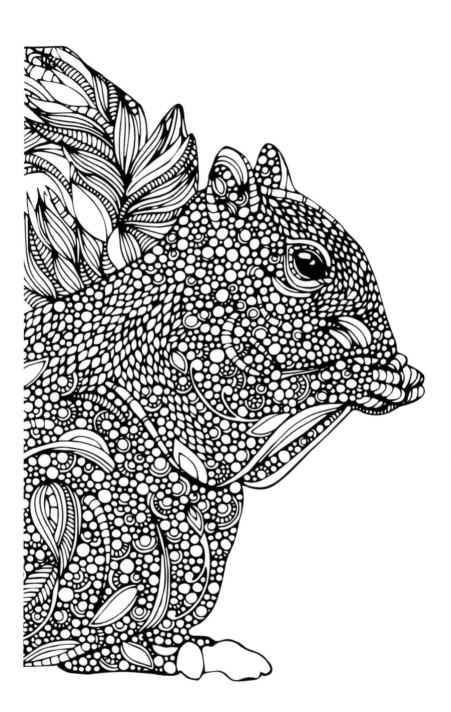

Choose a job you love,
and you will never have to work
a day in your life.

—Unknown

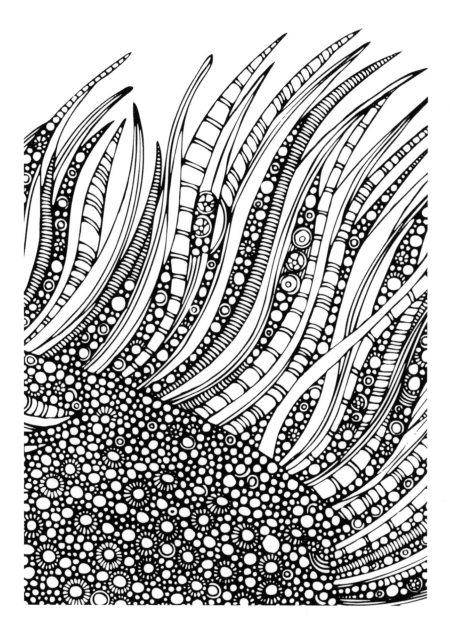

Smell the sea and feel the sky, let your
soul and spirit fly into the mystic.

—Van Morrison

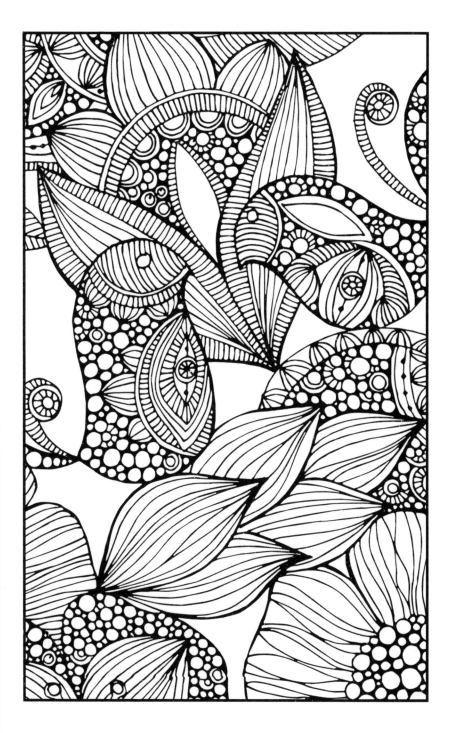

Dream higher than the sky and
deeper than the ocean.

—Unknown

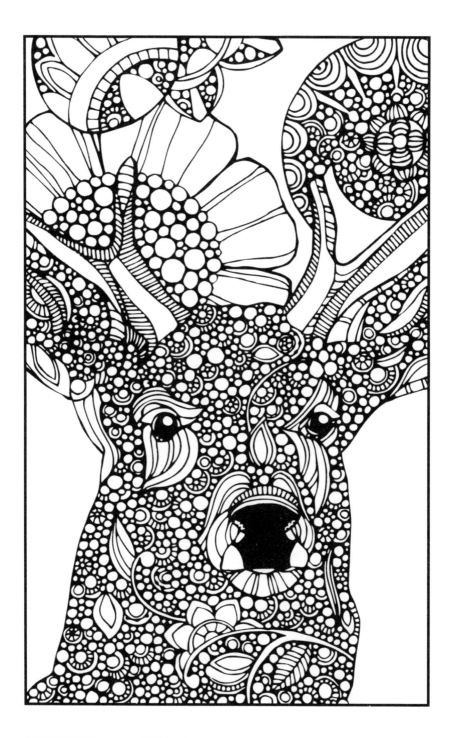

Trust yourself, you know more
than you think you do.

—Benjamin Spock

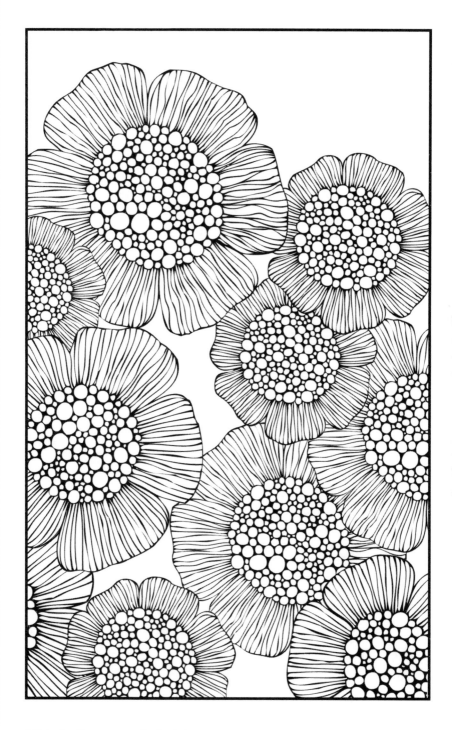

In joy or sadness flowers
are our constant friends.

—Kakuzō Okakura

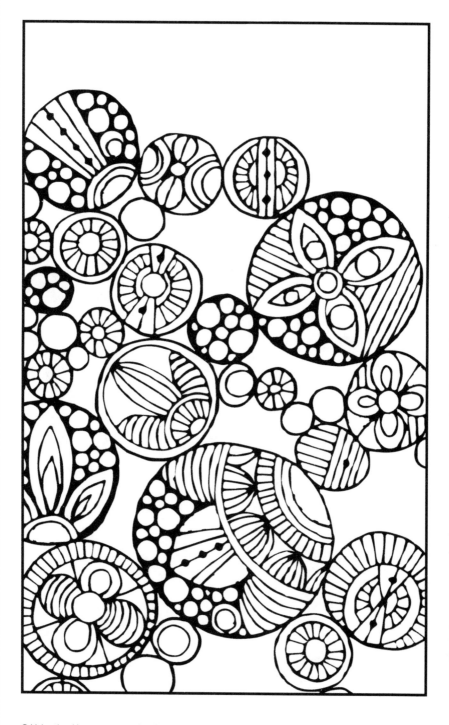

Why fit in, when you were
born to stand out?

—Mia Hamm

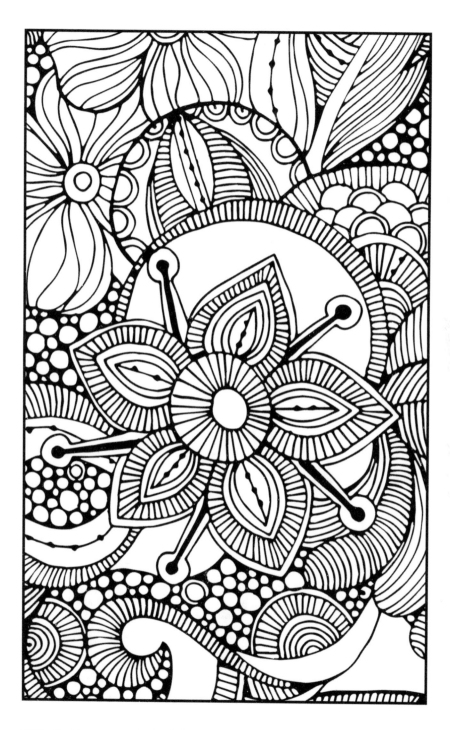

© Valentina Harper, www.valentinadesign.com

I must have flowers, always, and always.

—Claude Monet

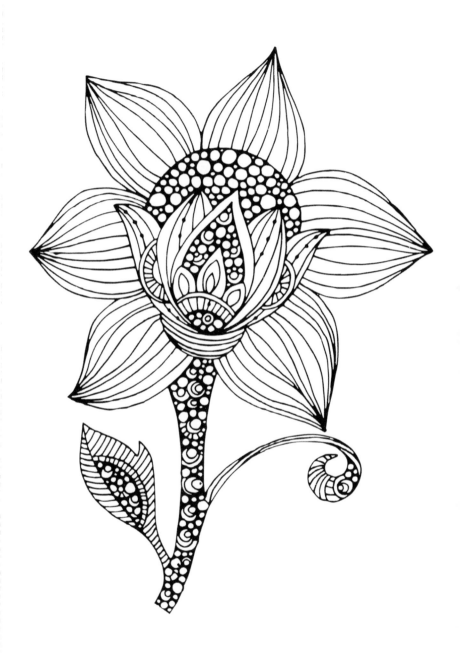

There are far, far better things ahead
than any we leave behind.

—C.S. Lewis

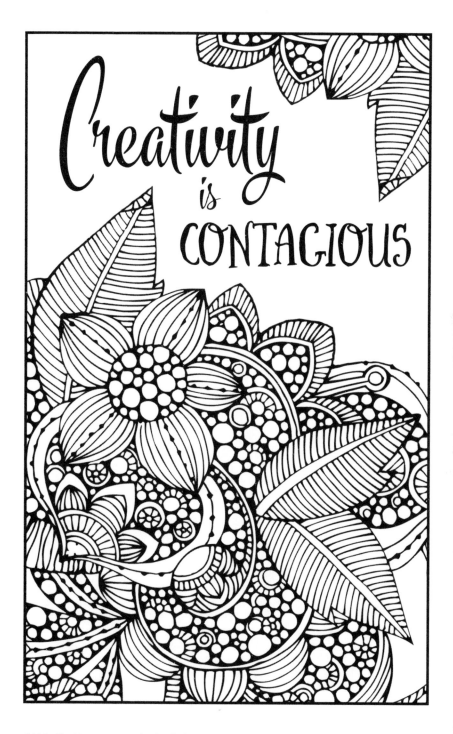

At first dreams seem impossible,
then improbable, then inevitable.

—Christopher Reeve

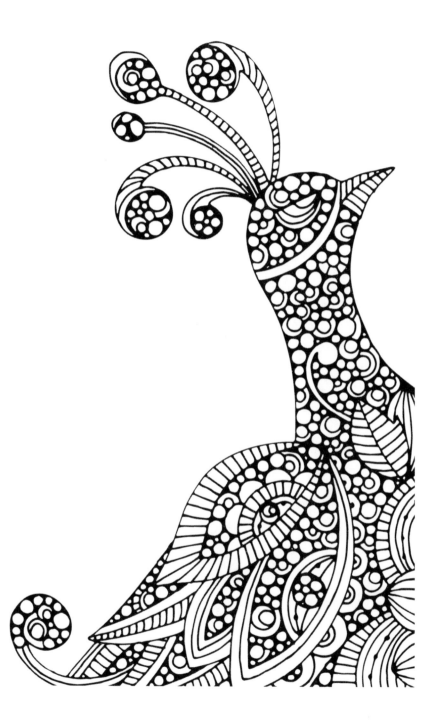

Be proud of who you are rather
than what you have.

—Unknown

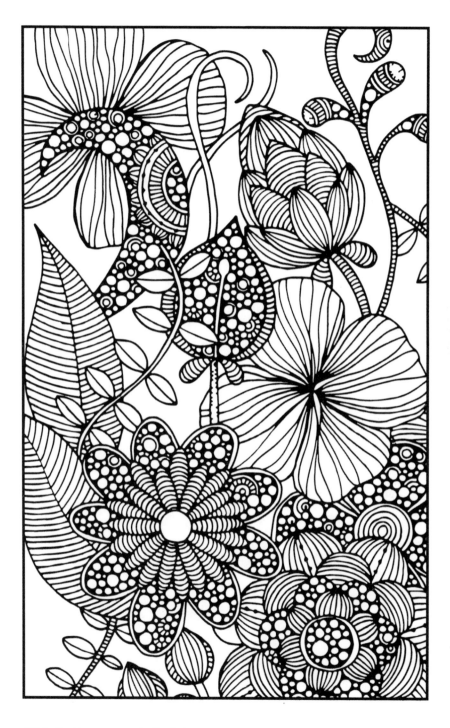

What you seek is seeking you.

—Rumi

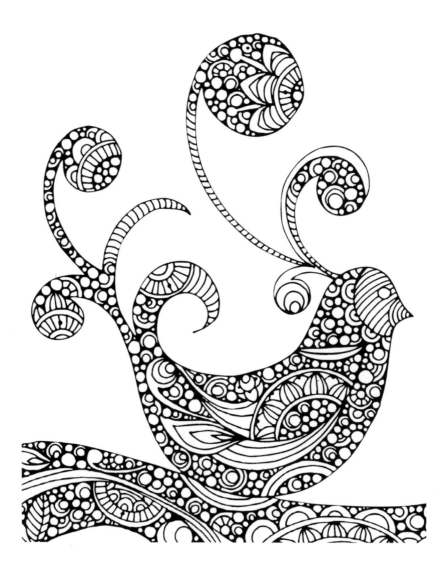

Keep a green tree in your heart and
perhaps a singing bird will come.

—Chinese proverb

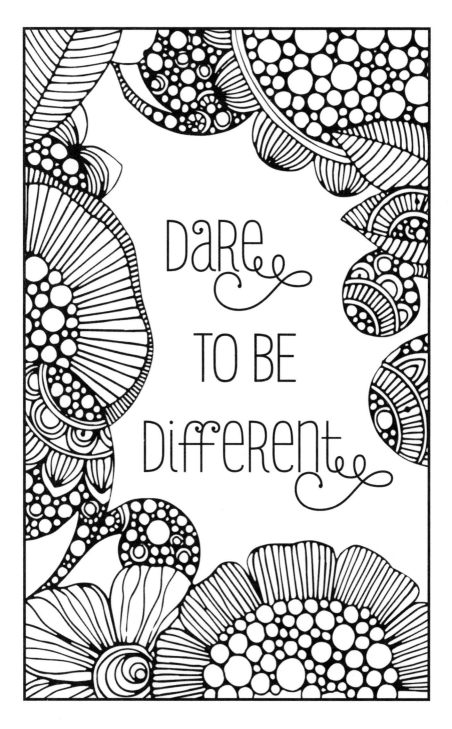

I've decided to be happy, because
it is good for my health.

—**Voltaire**

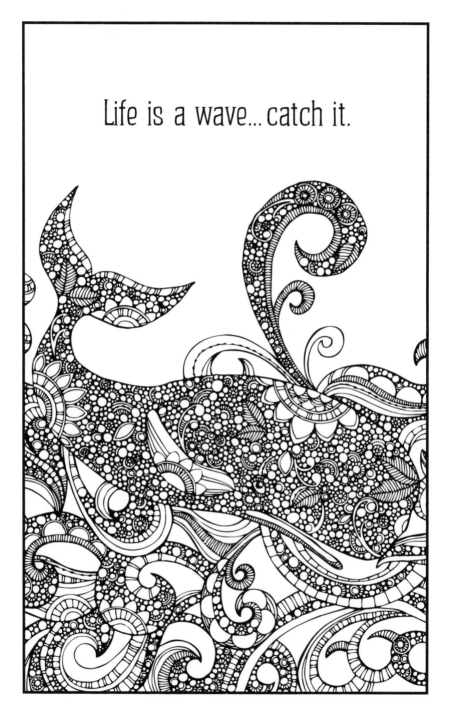

Life is a wave... catch it.

You can never cross the ocean
unless you have the courage
to lose sight of the shore.

—Unknown